D0746626

Trudeau: La Vie en Rose

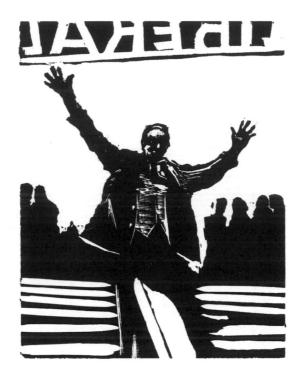

TRUDEAU

LA VIE EN ROSE

George A. Walker

The Porcupine's Quill

Library and Archives Canada Cataloguing in Publication

Walker, George A. (George Alexander), 1960–. Artist
 Trudeau : la vie en rose / George A. Walker.

ISBN 978-0-88984-386-8 (paperback)

 1. Trudeau, Pierre Elliott, 1919–2000—Comic books,
strips, etc. 2. Prime ministers—Canada—Biography—Comic
books, strips, etc. 3. Canada—Politics and government—
1968–1979—Comic books, strips, etc. 4. Graphic novels.
I. Clarke, George Elliott, 1960–, writer of introduction
II. Title. III. Title: Vie en rose.

FC626.T7W34 2015 971.064'4092 C2015-906352-3

1 2 3 • 17 16 15

Published by The Porcupine's Quill, 68 Main Street,
PO Box 160, Erin, Ontario NOB 1TO. http://porcupinesquill.ca

Represented in Canada by Canadian Manda.
Trade orders are available from University of Toronto Press.

We acknowledge the support of the Ontario Arts Council and
the Canada Council for the Arts for our publishing program.
The financial support of the Government of Canada through
the Canada Book Fund is also gratefully acknowledged.

Canada Council Conseil des Arts
for the Arts du Canada

ONTARIO ARTS COUNCIL
CONSEIL DES ARTS DE L'ONTARIO
an Ontario government agency
un organisme du gouvernement de l'Ontario

Canadä

Ontario
Ontario Media Development
Corporation

CONTENTS

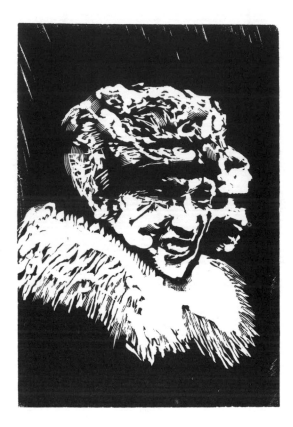

JE T'AIME, PAPA

I was about six years old when, with my father and my grandpa Sinclair, I went to the North Pole on my first official government trip. It was a very glamorous destination, but the best thing about it was that I was going to be spending lots of time with my dad. In Ottawa he worked so hard that I never saw him as much as I wanted.

We arrived in Alert, Canada's northernmost point, at a scientific military installation that seemed to consist entirely of low shed-like buildings and warehouses. I was getting a little bored because Dad still had a lot of work to do, when I was bundled up into a Jeep and hustled out on a special top-secret mission. I figured I was finally going to be let in on the reason for this high-security Arctic visit, and I was right. We drove slowly past the buildings, all of them very grey, until we rounded a corner and came upon a red one. The Jeep stopped. I started to walk across the snow to the front door but was told to go to the window. So I clambered over the snowbank, was boosted up to the window and rubbed my sleeve against the frosty glass to see inside. As my eyes adjusted to the gloom, I saw a figure hunched over one of many worktables that all seemed cluttered. He was wearing a familiar red suit with a furry white trim. And that's when I first understood just how powerful and wonderful my father was.

Pierre Elliott Trudeau. The very words convey so many things to so many people: statesman, intellectual, professor, adversary, outdoorsman, lawyer, journalist, author, prime minister. But more than anything, to me he was Dad. And what a dad! He loved us with the passion and devotion that

encompassed his life. He taught us to believe in ourselves, to stand up for ourselves, to know ourselves and to accept responsibility for ourselves. We knew we were the luckiest kids in the world. And we had done nothing to deserve it. It was instead something that we would have to spend the rest of our lives working very hard to live up to.

He gave us a lot of tools. We were taught to take nothing for granted. He doted on us but didn't indulge. Although many people say he didn't suffer fools gladly, he had infinite patience with us. He encouraged us to push ourselves, to test limits, to challenge anyone and anything—but there were certain basic principles that could never be compromised.

When I was in grade 3, I had a chance to visit my dad at work and have lunch in the Parliamentary Restaurant. It seemed to be full of serious people, most of whom I didn't recognize. I did recognize someone—one of my father's chief rivals. Thinking it would please my father, I told a joke about him—a generic, silly little grade-school thing. My father looked at me sternly with that look I would learn to know so well, and said: 'Justin, never attack the individual. We can be in total disagreement with someone without denigrating them as a consequence.' Saying that, he stood up and took me by the hand and brought me over to introduce me to the man, who was eating lunch with his daughter, a girl a little younger than I was. The man spoke to me in a friendly manner. It was at that point I understood that having opinions which are different from those of another person does not mean we can't like and respect the other person as an individual.

My father taught me that simple tolerance is not enough. We need genuine and deep respect for each and every human being as a human being, regardless of their politics, their values, their beliefs, or their origins. That's what my father

demanded of his sons, and that's what he demanded of his country. He demanded this out of a sense of love: love of his sons, love of his country; and that's why we still love him so. My father's fundamental beliefs never came from a textbook. They stemmed from his deep love for and faith in all Canadians. He left politics in 1984. But he came back for Meech. He came back again for Charlottetown. He came back to remind us of who we are and what we're all capable of. But he won't be coming back anymore. It's up to us, all of us, now.

The woods are lovely, dark, and deep. He has kept his promises and earned his sleep. Je t'aime, Papa.

— Justin Trudeau

This essay is adapted from Justin's eulogy, given on October 3, 2000.

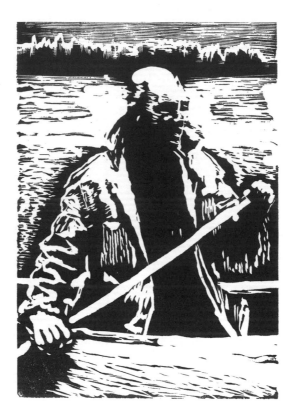

NO GREY AREAS:

PIERRE ELLIOTT TRUDEAU
IN BLACK AND WHITE

A woodcut image is made up solely of black-and-white contrasts. It refutes grey areas and the haze of subterfuge. It is plain, stark art, and so it is the perfect medium for mirroring the life of Canada's fifteenth prime minister, the Right Honourable Pierre Elliott Trudeau.

Like Walker, I'm a child of the 1960s, and so my political and intellectual vision has been honed by the fashions of thought and purpose that Trudeau brought to his premierships (1968–79, 1980–84). It was impossible to avoid his influence. The politician who comes alive again in the pages of this book was certainly not like any other—before or since—to strut into the House of Commons or dance into 24 Sussex Drive. He was unprecedented; he remains singular. Charismatic, photogenic, quick with a quip and flexible in pose, posture and style, he seemed as utterly at ease in his own skin as he was in buckskin—or in a tux. His character appeared dramatically un-Canadian. Unlike his predecessor, Prime Minister Lester B. Pearson, who survived two minority parliaments, he was no master of compromise.

Perhaps the big difference between Trudeau and other prime ministers is that he came to politics not merely from law offices or a career in business, but from the intelligentsia—the Quebec, bilingual elite—that was grappling with critical issues in the modern era: the relationship between the citizen and the state, the strife between capital and labour, the conflict between rights and rules, law and

liberty and, of course, between cosmopolitanism and nationalism. Trudeau became a politician after brooding over the Constitution and after advancing his ideas through both civic action (audit his anti-conscription speech in 1942 or his Asbestos Strike lectures in 1949) and journalism (see his incisive and witty squibs for that historic and formidable magazine of debate, *Cité Libre*. Indebted more to Montesquieu than to Marx, Trudeau's essays remain lively and insightful six decades later, because he refuses compromise and rejects ambiguity: he wants Quebec to become an open society so he can breathe freely! He wants Liberty!

So, when Trudeau began to be visible to English Canadians in the mid-1960s, he was fresh from frontline battles in Quebec for more democracy, more liberty, more economic progress. He knew that politics wasn't just about secret handshakes, but about the public implementation of progressive dreams. He had travelled further, literally and metaphorically, than likely any other Canadian politician of his time. He had seen and studied how other people lived and how they had chosen to arrange their societies and assert their cultures.

Certainly, his youthful flirtation with anti-Semitic fascism (a common malady of Québécois intellectuals rejecting atheistic communism as a panacea for Anglo-Saxon imperialism and robber-baron capitalism) had been educated out of him at Harvard University and the London School of Economics, and confirmed by his backpacking tour of the globe in 1948–49. That latter experience, during which he witnessed the birth of Israel and the struggles of India, Pakistan and China to emerge from centuries of Western imperialism, exploitation and oppression, also rendered him a man modernist in education, but postmodernist in orientation. Trudeau's journey made him an internationalist individualist. Thus, he was prepared to let 'a hundred flowers blossom, a

hundred schools of thought contend' (Mao)—in the mode of multiculturalism socially and in the mode of the thousand-channel-universe technologically. In other words, he became a forerunner of 'diversity' himself, adopting sandals here and a turban there to affirm the ultimate unity of human experience.

Apart from the personal education gleaned from his travels, Trudeau was shaped, above all, by the energies released as French Canadians in Quebec began to conceive of themselves as Québécois and to express a desire to replace Anglo-Saxon capitalists with their own francophone bourgeoisie as the legitimate governors of La Belle Province. This process is now known as the Quiet Revolution, and its purpose was encapsulated in the 1960 Quebec election slogan of the triumphant Liberal Party: 'Devenons Maîtres Chez Nous' (Let's become the masters of our own house).

Trudeau feared that the once-insular Quebec would become an aggressively nationalist state, suppressing minority rights. He envisioned a federalism that would allow francophone-majority Quebec to develop itself via the powers granted provinces under the Constitution, while the federal government protected Anglo language rights in Quebec and asserted French language rights across the rest of Canada. And, if francophone Quebecers could be persuaded to participate in the governance of Canada as a whole, they would be less likely to focus their energies on becoming the founders and leaders of an independent—and perhaps myopically nationalist—Quebec. The best example of Trudeau's argument was, of course, himself.

To my mind, the greatest revolutionary change brought about by Trudeau is that he introduced to English-Canadian culture and politics hitherto invisible but transformative figures from French literature and Québécois culture: the

flâneur, the *boulevardier*, the *chevalier*, the absurdist, the existentialist, the prankster, the situationist, the *nègre blanc*, the hipster, the *pícaro*, the Don Juan, but also the Renaissance man of quotable scholarship, artistry in letters, athletic prowess, wilderness adventure and derring-do.

When English Canada began to notice Trudeau between 1965 and 1968—and, really, to fall a bit in love with his image—the timing was right. Expo 67 suggested that Canada was actually sexy, sophisticated and exciting, not only a land of plaid-jacketed lumberjacks and pipe-smoking fishermen; and Trudeau was a one-man World Expo, being bilingual, cerebral, a with-it globetrotter and an outdoorsman. But he was also a decent, Canuck answer to the glamorous and globally mourned American president John F. Kennedy, assassinated on November 22, 1963. So debonair and Cold War chivalric was Kennedy, with his Rat Pack cronies, Camelot brain-trust and Parisian-stylish First Lady, that Canadians could only look on with audible envy. Trudeau's entrée into Canadian national politics proved that we could have a 'Kennedy' all our own, one who could date Barbra Streisand and Liona Boyd and hang out with Marshall McLuhan and Fidel Castro.

What really made Trudeau unique in his time is that he seemed to be the politician best informed about the process of decolonization occurring in Quebec as well as in much of the rest of the world that had formerly been controlled by Britain, France, Spain, Portugal or the Netherlands. His answer to the radical wing of Quebec's decolonization parties was eminently 'Canadian': a rewriting of the British North America Act of 1867 to emphasize rights, freedoms and the powers of people versus states. The 1982 patriation of the Constitution and its revision as the Canada Act with an entrenched Charter of Rights and Freedoms and an Amending Formula,

overriding provincial objections—particularly from Quebec—represented Trudeau's historic political accomplishment, even if it was resolutely apolitical, in the sense that it answered provincial demands for greater powers and more autonomy with an appeal to reason over passion. Constitutional reform, not popular revolution, was the way forward.

Personally, I wish that Trudeau had understood better the aspirations of the First Nations to realize greater prosperity, dignity and equality. By the time he had begun to acquire that vision, however, he was no longer an empowered politician, but a statesman, returned to editing a revived *Cité Libre* and again battling philistinism, not with legislation, but with essays tinged with poetry.

— George Elliott Clarke, OC, ONS, PhD
E. J. Pratt Professor of Canadian Literature
University of Toronto

THE TRUDEAU YEARS
IN 80 WOOD ENGRAVINGS

Looking back to the Trudeau years, I can't help but be nostalgic for the optimism I felt in those formative times. I was seven years old when Trudeau was first elected in the spring of 1968. One of my favourite TV shows was *Here Come the Seventies*, which was all about the fabulous future I was about to experience. I was positive we were going to see a hotel on the moon and be in flying cars by the 1980s. Although those dreams didn't quite turn into reality, I associate the era with Trudeau because he symbolized the changing times and our hope for the future.

My parents, aunt and cousins were all fascinated by this flamboyant guy named Pierre Elliott Trudeau. They saw him as the only one who could unite our precarious country. Bombs were going off in Quebec, a war raged in Vietnam, civil unrest was rampant in the United States and the threat of nuclear war from the Soviet Union loomed over us. Trudeau understood that we wanted change, recognition of our multicultural country and a chair on the international stage.

Today, it is next to impossible to capture the spirit of that era through words alone. It was a time of profound transformation for Canada both culturally and politically. In this wordless narrative of the life and times of Pierre Trudeau I have tried to capture the visual culture of the day through the language of images. I found I could communicate things with black-and-white engravings that I could not adequately express with words. The Pulitzer Prize–winning cartoonist

Art Spiegelman said it best: '*Wordless novels are filled with language, it just resides in the reader's head rather than on the page.*'

For help in the creation of this wordless narrative I am indebted to George Elliott Clarke for his valuable advice and suggestions for engravings. Justin Trudeau graciously provided a tribute to his father that adds a personal insight into Trudeau's character. Tom Smart has written a thoughtful endnote and I have added a chronology.

Ultimately, the goal of the visual narrative is *not* to illustrate words but to be independent of them and so provide the reader with an alternative language with which to comprehend and interpret the story.

— George A. Walker

To help the reader place images
in the context of events, locations and names,
a brief chronology may be found on page 181.

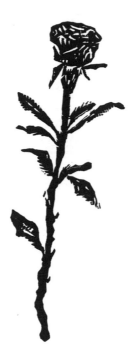

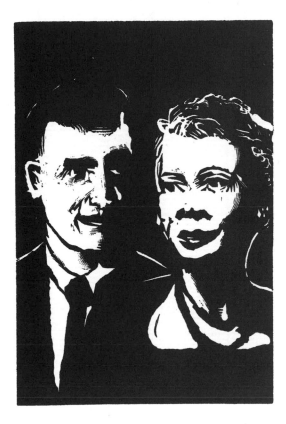

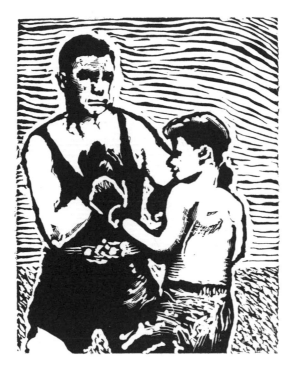

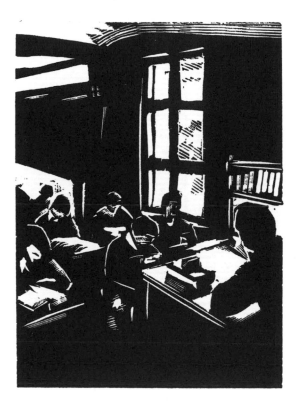

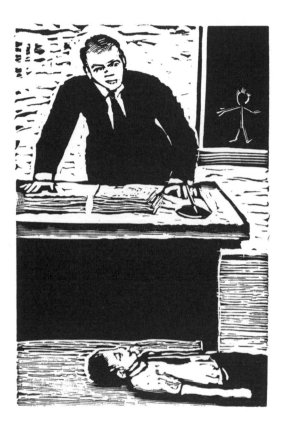

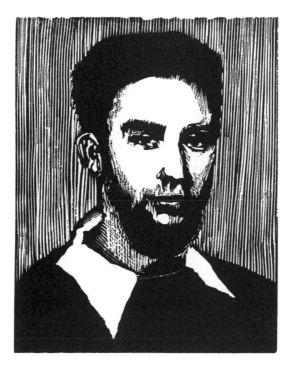

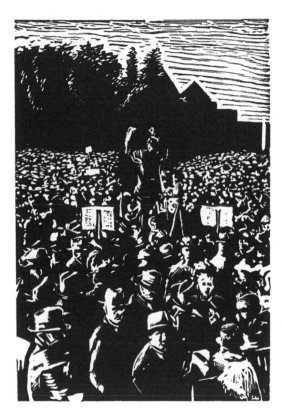

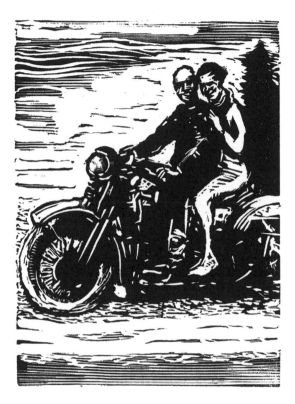

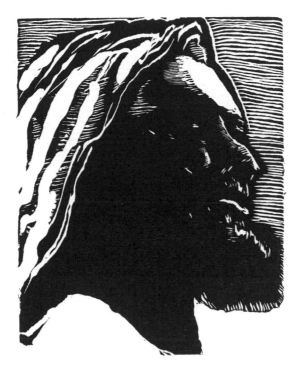

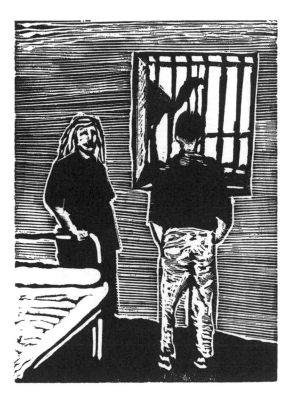

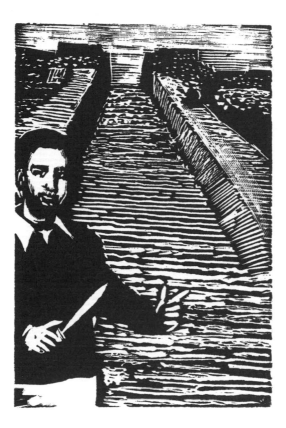

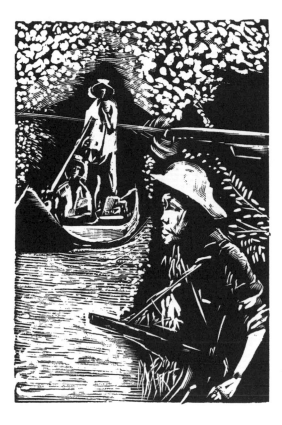

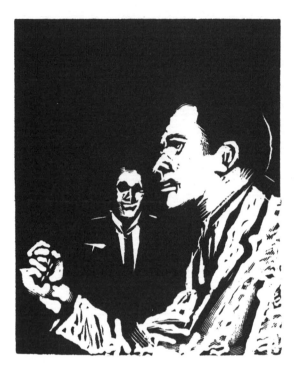

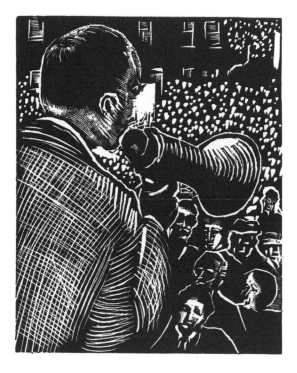

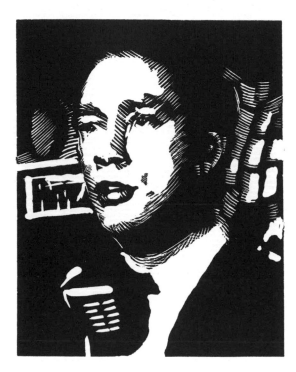

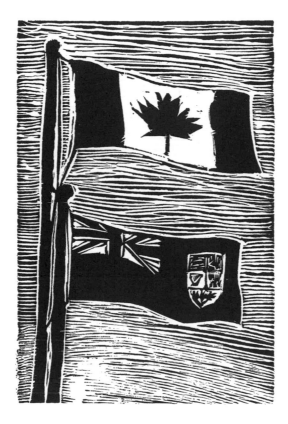

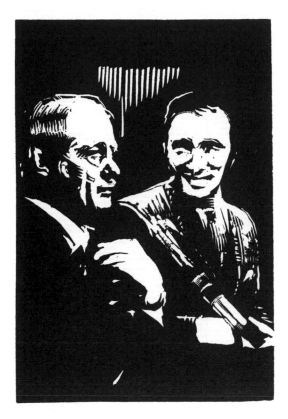

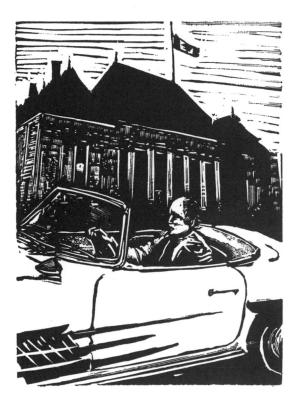

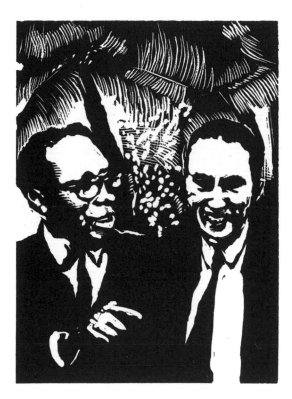

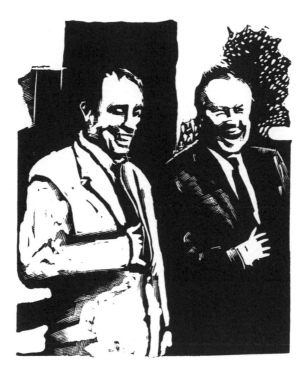

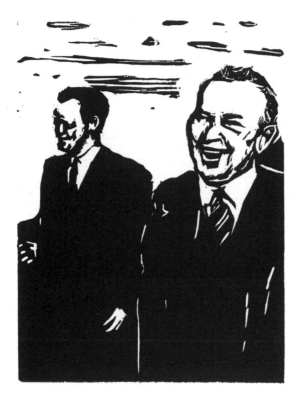

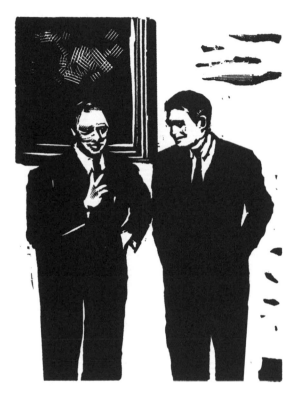

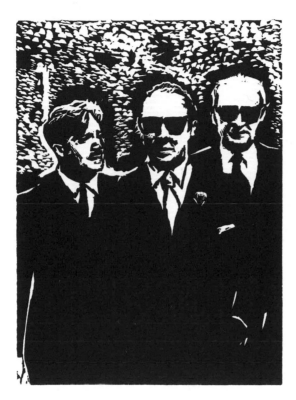

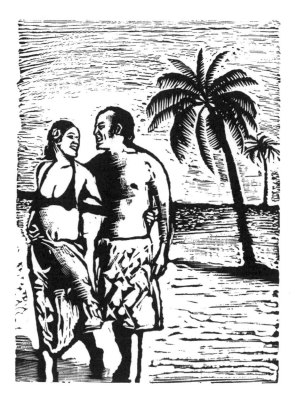

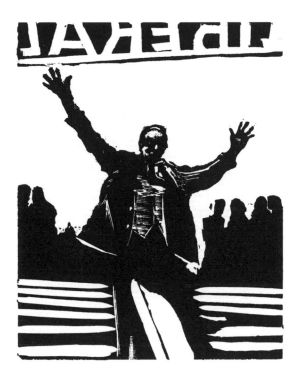

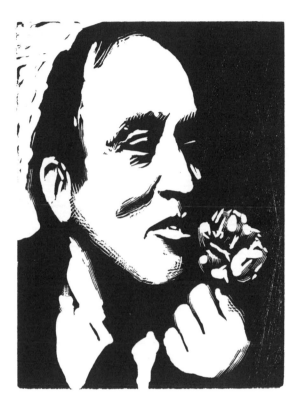

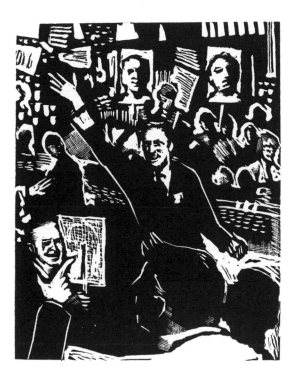

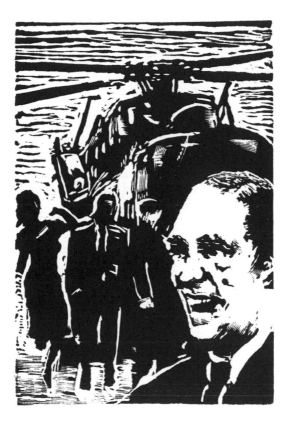

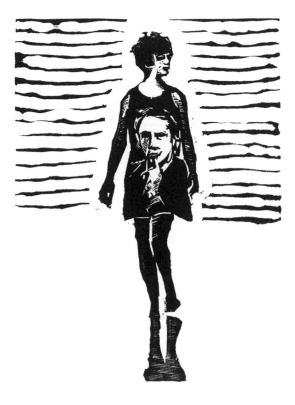

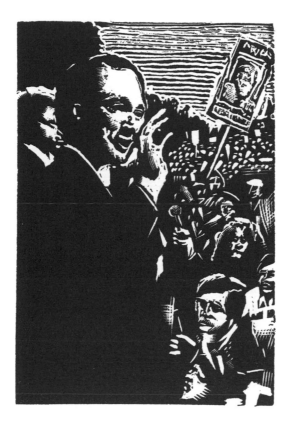

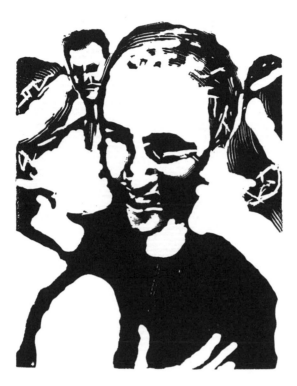

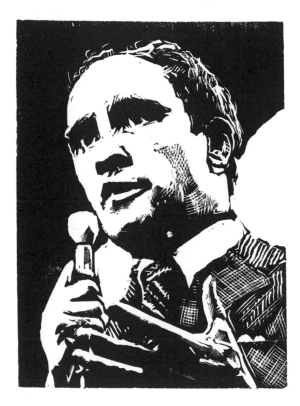

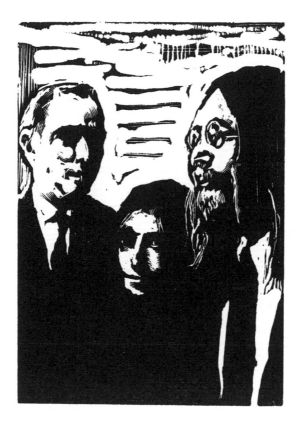

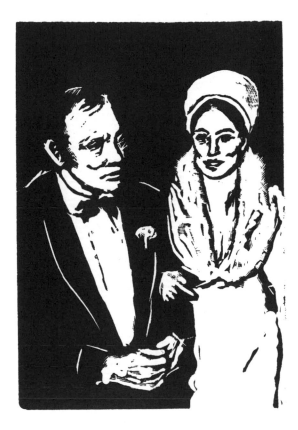

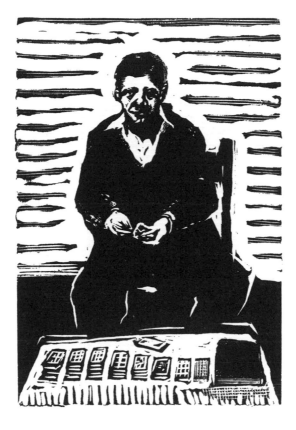

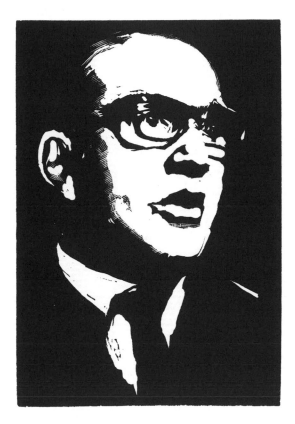

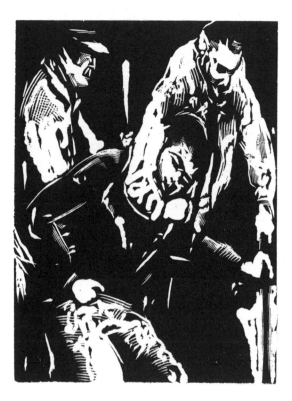

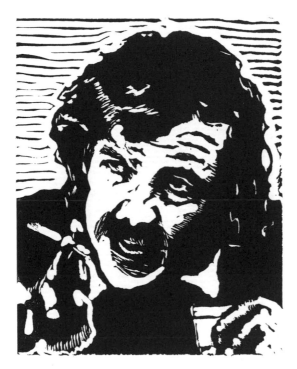

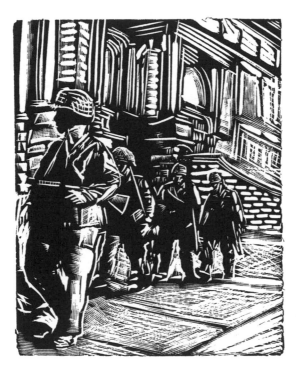

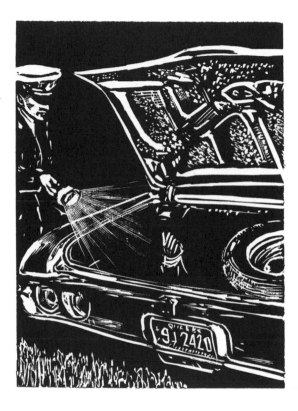

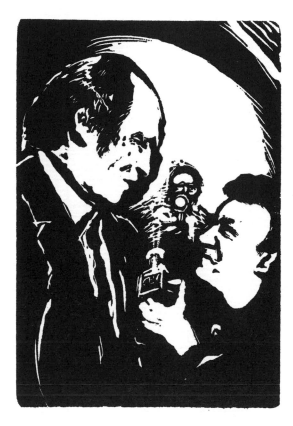

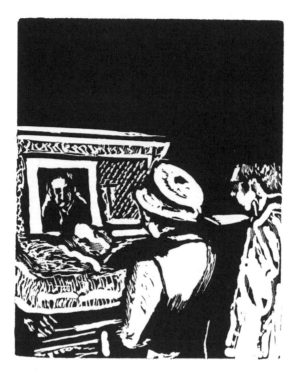

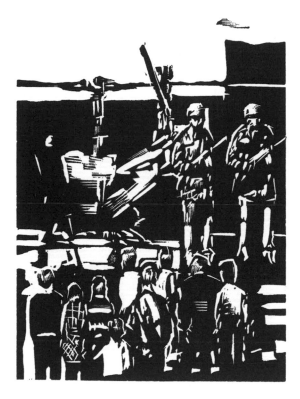

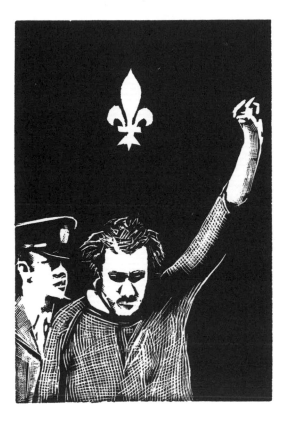

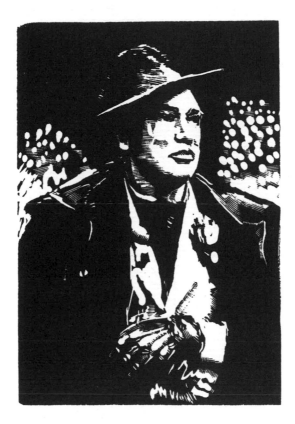

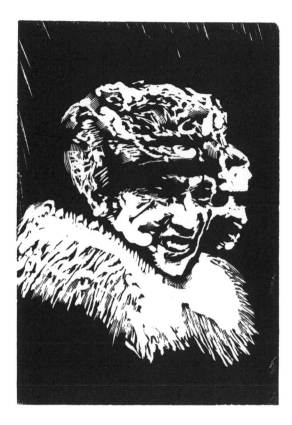

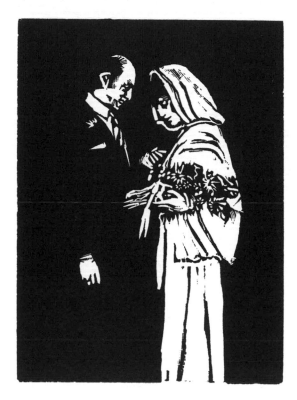

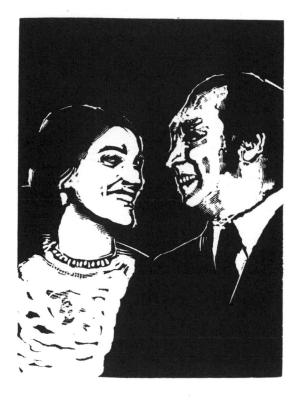

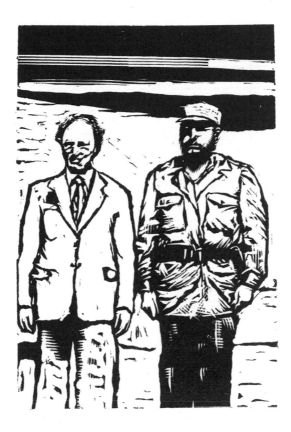

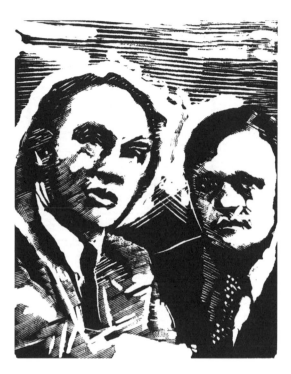

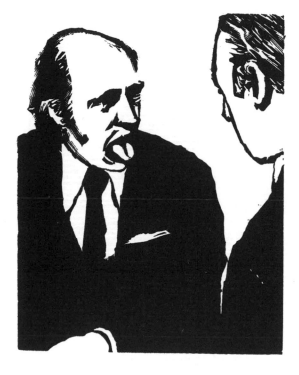

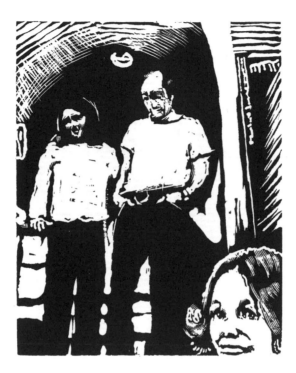

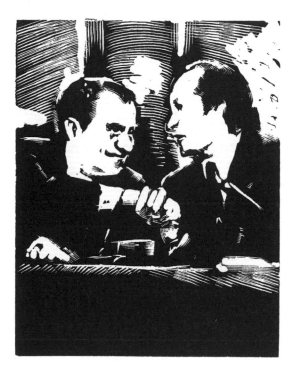

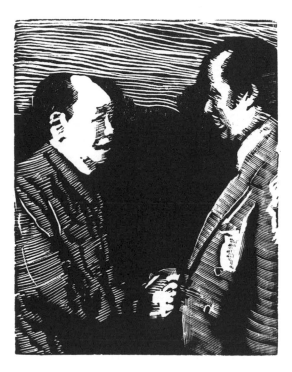

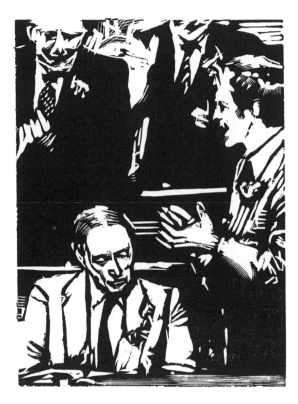

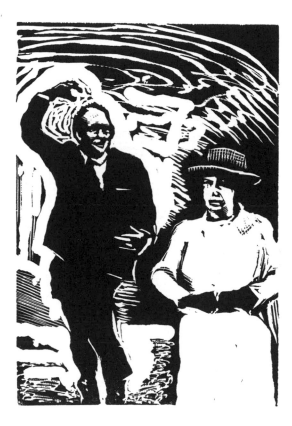

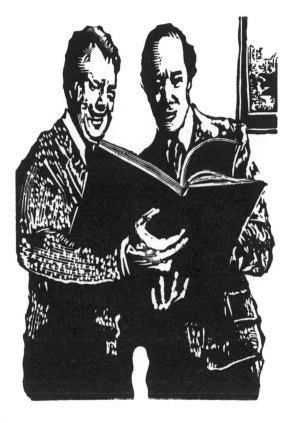

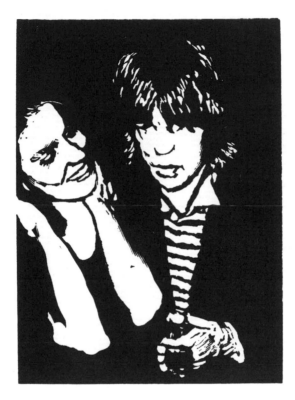

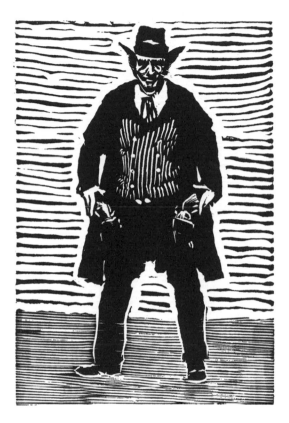

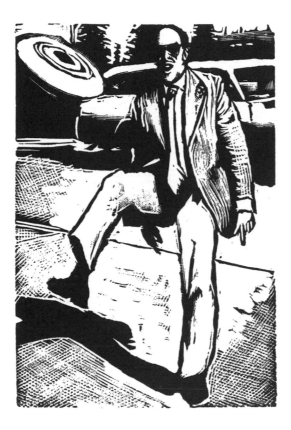

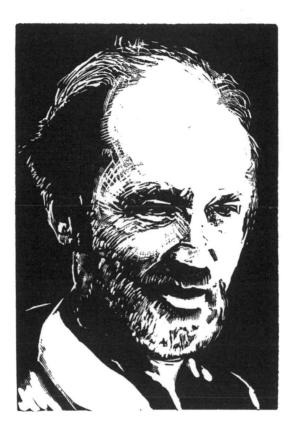

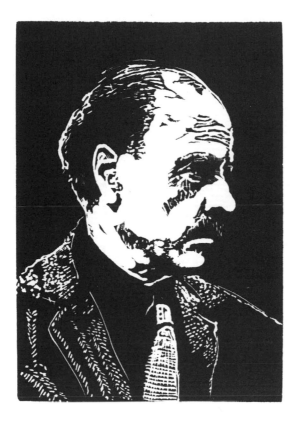

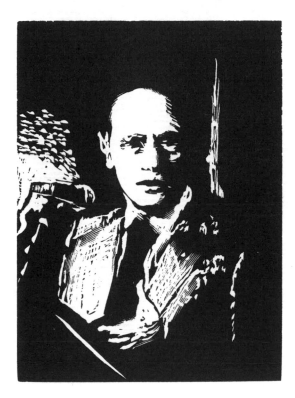

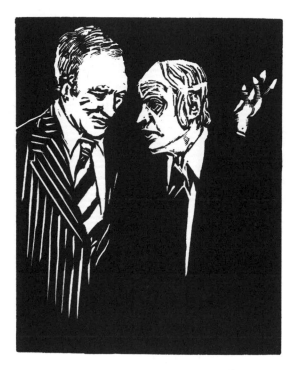

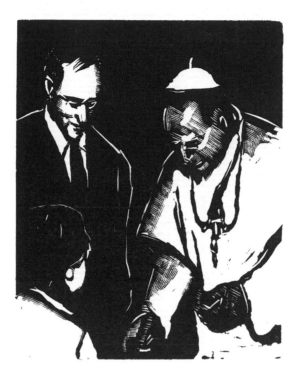

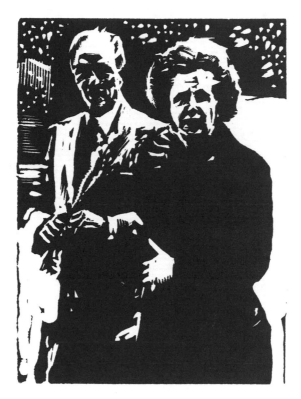

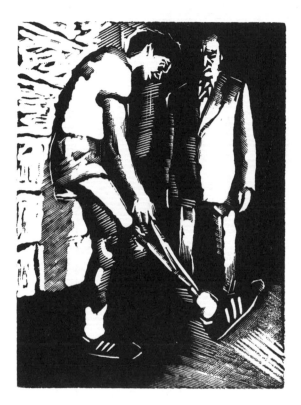

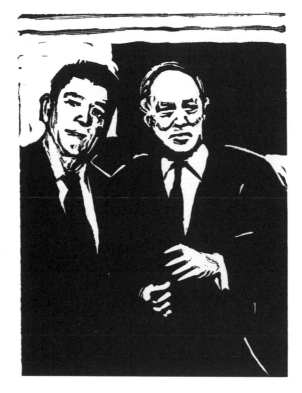

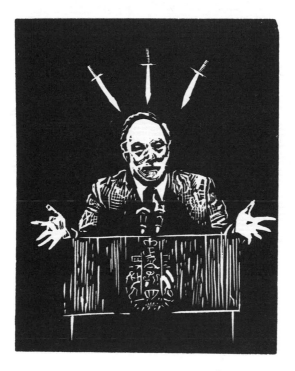

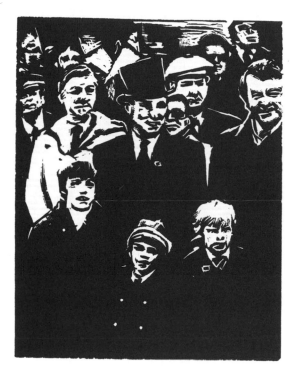

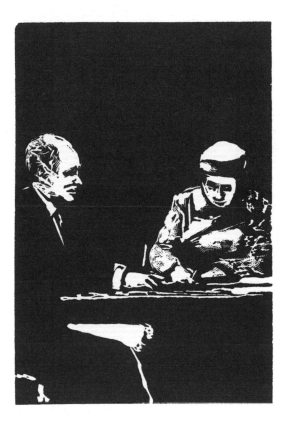

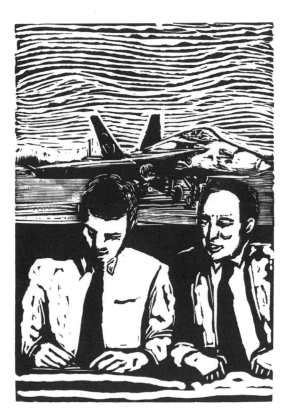

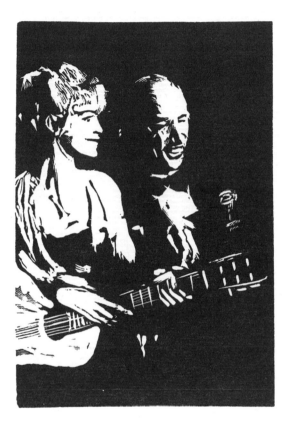

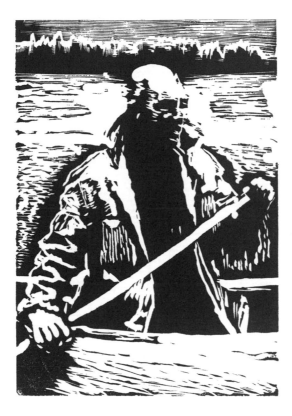

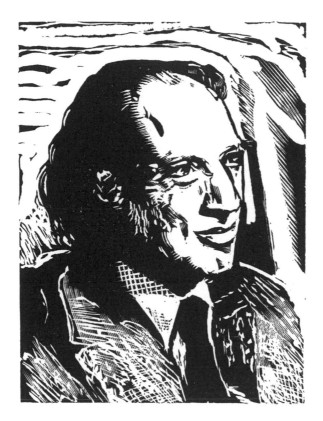

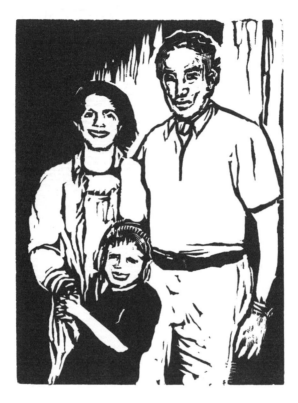

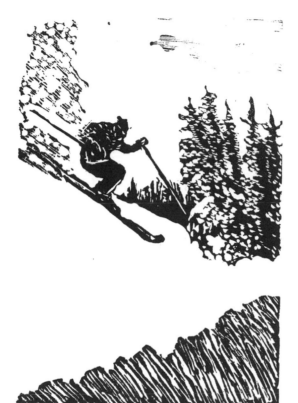

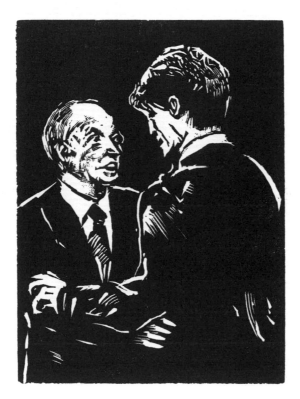

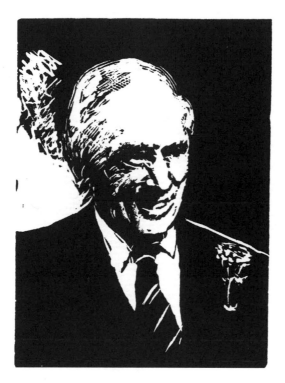

CHRONOLOGY

21. Pierre Trudeau was famous for wearing a rose in his lapel. Of course, the rose has long been a symbol of love and passion—two characteristics easily associated with Trudeau, given his love for Canada and his passion for politics. Yet the rose also represents confidentiality. The phrase *sub rosa* (under the rose) was hung from a ceiling at a meeting to remind attendees to use discretion when discussing subjects therein.* In Christianity these words have a special place in confessions, and the rosary is considered a symbolic wreath of red, white and yellow roses. In ancient Rome, roses were grown in the funerary gardens to symbolize resurrection. Moreover, the thorns of the rose have represented suffering and sacrifice and the sins wrought by the Fall from Paradise. All these meanings make the rose a fitting symbol to preface this wordless narrative of the life and times of Pierre Elliott Trudeau.

* In the middle ages a rose was hung from the ceiling in council chambers. Some maintain that *sub rosa* comes from the plotting and counter-plotting between the Houses of York and Lancaster. During the the War of the Roses (1455–1485) those from the House of Lancaster wore a red rose in their caps. It was suggested that the wearing of the rose indicated that conversations be kept secret and confidential. (From Monica-Maria Stapelberg's *Strange But True: A Historical Background to Popular Beliefs and Traditions*, p. 245.)

23. Joseph Charles Émile Trudeau and Grace Elliott were Pierre's parents. Joseph was a lawyer and entrepreneur. His death, on April 10, 1935, had a profound effect on the young Pierre, who later said, 'He was the focal point of my life, and his death created an enormous void' (*Memoirs*, p. 30). Trudeau's mother, Grace Elliott, was of French and Scottish descent; she had two other children: Pierre's older sister, Suzette, and his younger brother, Charles, Jr. (Tip). Pierre was very close to his mother.

25. As a child, Trudeau acquired a reputation as a fighter. His father loved sports, especially boxing, and enjoyed giving his eldest son lessons. On one occasion, Joseph Trudeau brought the featherweight champion Léo 'Kid' Roy to the family's summer home. Roy showed off his prize belt to young Pierre, who feinted a few punches with the champ.

27. Pierre attended the prestigious Jesuit Collège Jean-de-Brébeuf in Montreal, where he absorbed teachings promoting Quebec nationalism.

29. Pierre was a scholar, but also a prankster. He and his friends often 'played dead', falling down while the teacher looked on in pained dismay.

31. Trudeau earned his law degree at the Université de Montréal in 1943. During his studies, he had to join the Canadian Officers Training Corps. In 1947, Trudeau moved to Paris to continue the dissertation work he had begun at Harvard. Trudeau was influenced by Nikolay Berdyayev, whose book, *Slavery and Freedom* (1939), moved him to reject nationalism and separatism. Trudeau abandoned his Paris studies to undertake a doctoral program under the tutelage of the

renowned socialist economist Harold Laski at the London School of Economics.

33. In his 20s, Trudeau was anti-conscription and made a passionate speech to that effect to a rally in 1942. This speech put him—for the first time—on the front page of Quebec's newspaper of record, *Le Devoir*. He sported a bow tie and called for 'revolution'.

35. At the age of 22, Trudeau bought himself a Harley-Davidson motorbike, the iconic symbol of rebellious youth.

37. In the late 1940s, as the Iron Curtain descended, Trudeau spent a year backpacking throughout Eastern Europe, the Middle East, and the Far East, often wearing the garb of the locals.

39. In Jordan, Trudeau was arrested on suspicion of being an Israeli spy. He spent some time in jail before being released.

41. While passing through Ur, Iraq, in 1948, Trudeau decided he wanted to climb the ziggurat, a towering pyramid in the desert. He made his way to the top only to find he was not alone. Two bandits had followed him and now demanded money. The resourceful Pierre snatched a knife from one of the bandits and frightened his pursuers by shouting Jean Cocteau's verses about antiquity. As the young Trudeau gestured with the knife and wildly recited poetry, he so terrified the bandits that they skedaddled.

43. While in Indochina, travelling on a river in a sampan, Trudeau was shot at by pirates. Fortunately, he eluded them in the river fog.

45. The Asbestos Strike of 1949 was a four-month-long labour dispute by asbestos miners. This turning point in Quebec history helped spark the Quiet Revolution (a realignment of politics into federalist and sovereignist factions).

47. The strike launched the political careers of Jean Marchand, Gérard Pelletier and Pierre Trudeau (aka 'the three wise men').

49. Pierre Trudeau: 'I'll laugh at fame, ignore the bank, / Annoy all fools, and cowards spank.' (From George Elliott Clarke's *Trudeau: Long March, Shining Path*, p. 44.)

51. The old Canadian Red Ensign is replaced by the Maple Leaf flag on February 15, 1965.

53. Trudeau interviewing René Lévesque on CBC's *This Hour Has Seven Days*. At the time, Trudeau was a professor of law at the University of Montreal and Lévesque was a veteran broadcaster. In December 1965, freelancer Trudeau, along with Larry Zolf, interviewed Lévesque for the influential television program.

55. On April 4, 1967, Trudeau was sworn into the Privy Council as justice minister under Prime Minister Lester B. Pearson. Here he is in front of the Supreme Court building in Ottawa, driving his 1955 Mercedes 300SL.

57. As parliamentary secretary, Trudeau found himself a member of the Canadian delegation to the United Nations General Assembly. This image depicts him alongside President Léopold Senghor of Senegal.

59. Trudeau and Prime Minister Lester B. Pearson in 1967. In the second session of the 27th Parliament, on December 21, 1967, Trudeau introduced the omnibus Bill C-150, which decriminalized abortion, contraception and homosexuality. He quipped, famously, 'There's no place for the state in the bedrooms of the nation.'

61. Jean Chrétien (left) and Prime Minister Lester B. Pearson (right), 1967. This engraving and the next depict a prime minister with cabinet ministers who would eventually become prime ministers themselves. These four men (Pearson, Trudeau, Chrétien and Turner) held the leadership of the Liberal Party of Canada consecutively from 1958 to 2003.

63. Trudeau and John Turner (right), 1967.

65. The 'three wise men' (as they were known). Left to right: Jean Marchand, Pierre Trudeau and Gérard Pelletier, July 1967.

67. Vancouver born Margaret Joan Sinclair met Pierre Elliott Trudeau while vacationing in Tahiti in 1968. He was minister of justice at the time and 48 years old; Margaret was 18.

69. Trudeau slides down the banister in Ottawa's Château Laurier Hotel during the Liberal leadership convention.

71. Trudeau smells a rose during the leadership convention in April 1968. 'Even the great teachers, and I have sat in at the classes of some of the few, I think, in the world, are not as good as their books. I don't accept an excuse from students who say they can't learn because they haven't got great teachers and

because the teachers don't spend enough time with them. I think the basic fault is that the students don't spend enough time with their books.' —Pierre Elliott Trudeau, University of Manitoba, Winnipeg, December 13, 1968.

73. Waving after winning the federal Liberal Party leadership on April 6, 1968. Trudeau's victory made him the sixth Liberal prime minister of Canada. Two weeks later, Trudeau asked the Governor-General to dissolve Parliament and call a federal election.

75. Trudeau arriving by helicopter for an election campaign appearance.

77. Paper dress from the 1968 campaign.

79. Campaign speech in 1968. Trudeau's campaign poster image is reminiscent of the Ché Guevara poster popular at the time. One reporter said of 'Trudeaumania': 'It's like electing a Beatle for Prime Minister.' Young people flocked to greet him; young women kissed him on the cheek; his audiences were rapturous with enthusiasm. The charismatic but very private Trudeau was bemused by it all, and his Liberals won the election, taking 155 seats to the Tories' 72.

81. Campaign kisses.

83. 'Canada regards herself as responsible to all mankind for the peculiar ecological balance that now exists so precariously in the water, ice and land areas of the Arctic archipelago. We do not doubt for a moment that the rest of the world would find us at fault, and hold us liable, should we fail to ensure adequate protection of that environment from pollution or

artificial deterioration.' —Pierre Elliott Trudeau, October 24, 1969, House of Commons, Debates.

85. Trudeau meeting with John Lennon and Yoko Ono, December 23, 1969. John Lennon said, 'If all politicians were like Mr. Trudeau, there would be world peace.' (From Pierre Elliot Trudeau's *Memoirs*, 1993.)

87. Trudeau dated Barbra Streisand, 1969 to 1970.

89. British Trade Commissioner James Cross was kidnapped by the Front de Libération du Québec (FLQ) in October 1970. Here he is playing solitaire while held hostage.

91. Pierre Laporte was Quebec's deputy premier and minister of labour when kidnapped by members of the FLQ on October 10, 1970. A week later, his strangled body was found in the trunk of a car. His kidnappers had demanded the release of 23 'political prisoners' in exchange for his freedom.

93. Civil unrest roiled Quebec. The FLQ had claimed responsibility for more than 90 bombings—including that of the Montreal Stock Exchange on February 13, 1969, in which 27 people were injured.

95. Robert Lemieux was attorney for several defendants in the October Crisis. During one rally, some 3,000 people gathered at the Paul Sauvé Arena to show support for the FLQ's separatist-inspired—though criminal—acts. Lemieux was quoted as saying, 'We're going to organize, choose our ground, and WE WILL VANQUISH.' Under the War Measures Act, he was jailed for four months on charges of seditious conspiracy.

97. Troops were summoned to protect state institutions and thus allow the police to focus on finding and rescuing the FLQ-held hostages.

99. On October 17, 1970, at the St. Hubert airport, the body of Pierre Laporte was found in the trunk of Paul Rose's car.

101. 'Just watch me,' Trudeau declared, as he used the War Measures Act to battle the FLQ.

103. Pierre Laporte's funeral, October 20, 1970.

105. The military 'occupies' Montreal. Children watch as soldiers stand guard. Trudeau said of the military presence: 'There's a lot of bleeding hearts around who don't like to · see people with helmets and guns. All I can say is "go ahead and bleed", but it's more important to keep law and order in this society than to be worried about weak-kneed people....'

107. Paul Rose, a leader of the radical Quebec sovereignty movement, was convicted of the kidnapping and murder of Quebec cabinet minister Pierre Laporte. Ten years later, in 1980, a Quebec government commission determined that Rose had not been present when Laporte was killed. Under the powers of the War Measures Act, many peaceful and innocent citizens were arrested and detained. Trudeau stated, 'On that night of Thursday the 15th and Friday the 16th of October, then, the government decided to resort to the War Measures Act. We did not take this decision lightly. For my part, I was deeply disturbed by it, and extremely apprehensive about what would ensue' (*Memoirs*, p. 142). In December 1970, Trudeau

announced that all War Measures Act troops stationed in Quebec would be withdrawn by January 5, 1971.

109. Trudeau at the November 28, 1970, Grey Cup game. The Montreal Alouettes won.

111. Trudeau in a fur hat at the Arctic Winter Games in Yellowknife, Northwest Territories, in 1970. Referring to the Arctic waters, Trudeau commented: 'I think there is a very great tendency to be carried away by the territorial imperative here. What can happen? Take some of our ice? Why do we want to own it? What is the danger up there now? Well, it is essentially pollution, I think. This is the latest kick, pollution. Everyone has got the pollution kick. So, we want to make sure that there is no pollution up there.' —CBC TV, *Under Attack*, February 24, 1970.

113. March 4, 1971. Pierre Elliott Trudeau married Margaret Joan Sinclair. Margaret made her own wedding dress.

115. Newlyweds Margaret and Pierre enjoying their first year as a couple.

117. Trudeau with President Fidel Castro during a state visit to Cuba in 1976.

119. Trudeau and Jean Chrétien in 1972. During the October Crisis, Chrétien had told Trudeau to 'act now, explain later'. Chrétien was strongly opposed to the Quebec sovereignty movement and was a keen supporter of official bilingualism and multiculturalism—policy ideals he shared with Trudeau. Trudeau gave Canadians the policy of multiculturalism in 1971.

121. Trudeau had a playful sense of humour, illustrated by an alleged expletive uttered in the House of Commons on February 16, 1971, that he explained, famously, was really the misheard phrase 'fuddle duddle'. On one television program during a campaign appearance in Kingston, Ontario, in 1972, Trudeau learned that the local candidate was a doctor. He stuck out his tongue so the doctor could check it, asking him, 'Do I look sickly?'

123. Trudeau campaigned relentlessly throughout the 1970s. Here, Margaret and he are touring by train on what *Le Devoir* called 'the Trudeau Express', his whistle-stop campaign through the Maritimes.

125. In April 1972, Trudeau signed an agreement with President Richard Nixon on water quality in the Great Lakes.

127. 1973. Trudeau shaking hands with Mao Zedong. As prime minister, he hoped to secure access to the Chinese market for Canadian businesses.

129. Trudeau received a standing ovation in the House of Commons for his speech in support of the abolition of capital punishment, June 15, 1976.

131. In 1977, Trudeau performed a cheeky pirouette behind Her Majesty Queen Elizabeth II.

133. President Jimmy Carter and Prime Minister Pierre Elliott Trudeau in 1977, admiring a Canadian book celebrating Canadian-U.S. friendship.

135. In March 1977, Mick Jagger brought the Rolling Stones to the El Mocambo tavern in Toronto. Margaret Trudeau was there, along with many other fans. Asked about her role as wife to the prime minister, she said, 'I want to be more than a rose in my husband's lapel.'

137. Trudeau as a gunslinger. During the 1979 campaign, he was seen as the gunslinger who had battled Western alienation and Quebec separatism and wasn't afraid to face René Lévesque in a Quebec sovereignty referendum showdown. But was he ready to do battle again?

139. Trudeau playing Frisbee at the Vancouver airport, May 16, 1979. Trudeau knew a trend when he saw one. He displayed his athleticism often when campaigning.

141. Trudeau sporting a beard, 1979. He would soon shave it off. On June 4, 1979, having lost the election to the Progressive Conservatives led by Joe Clark,* he resigned as prime minister. His marriage troubles and his demotion to leader of the opposition had him rethinking his future.

143. Portrait of Marshall McLuhan. The media guru, who supported Trudeau, told him that having a beard while campaigning served to 'cool' his political image several degrees; if he shaved, it would 'hot up' his charisma factor for positive gain.

* Joe Clark served as the 16th prime minister of Canada from June 4, 1979 to March 3, 1980. At the time he was the youngest person to become prime minister.

145. 1980 again found Trudeau on the campaign trail, soon to return as prime minister, now with a third parliamentary majority (out of five elections fought). On May 14, 1980, at the Paul Sauvé Arena in Montreal, he said, 'We won't let this country die, this Canada ... which really is, as our national anthem says, our home and native land. We are going to say to those who want us to stop being Canadians, we are going to say a resounding, an overwhelming—*no*.

147. René Lévesque wanted Quebecers to vote for separation, but Trudeau stood in his way. Still, Lévesque led the Parti Québécois to victory in the 1981 provincial election, increasing the popular vote from 41 to 49 percent.

149. Trudeau and son Justin meeting Pope John Paul II in Rome, June 1980.

151. Trudeau met Margaret Thatcher on June 25, 1980, about a month after Quebecers had rejected sovereignty association in a provincial referendum. In 1982, Trudeau was successful in patriating the Constitution through the passage of legislation that included an Amending Formula and the Charter of Rights and Freedoms.

153. Trudeau with cancer-research fundraiser and Canadian hero Terry Fox, in Ottawa, August 2, 1980.

155. Ronald Reagan and Pierre Trudeau at the seventh G7 Summit, known as the Ottawa Summit, which was held in Montebello, Quebec, July 20 and 21, 1981.

157. During the night of November 4, 1981 (leading up to the patriation of the Constitution in 1982), Trudeau reached

an agreement with nine provincial premiers which would transform the country. René Lévesque dubbed it 'the Night of the Long Knives'. Three of the 'blades' were Justice Minister Jean Chrétien and provincial Attorneys-General Roy Romanow of Saskatchewan and Roy McMurtry of Ontario, who locked in the final constitutional agreement. On November 5, 1981, nine premiers and Mr. Trudeau announced their agreement on a constitutional reform package.

159. Trudeau with sons Justin, Michel and Sacha, at the Remembrance Day ceremonies on November 11, 1981, in Ottawa.

161. The Queen signs the Constitution. Trudeau said: 'I wish simply that the bringing home of our constitution marks the end of a long winter, the breaking up of the ice jams and the beginning of a new spring. What we are celebrating today is not so much the completion of our task, but the renewal of our hope—not so much an ending, but a fresh beginning.' —Canada's Proclamation Ceremony, Ottawa, April 17, 1982.

163. Canada's first CF-18 fighter jets. The aircraft were part of a ceremony at the factory on July 28, 1982. The Canadian Forces officially accepted the aircraft on October 7. The prime minister signed the contract with the chief government negotiator/director of procurement of the New Fighter Aircraft Program.

165. New bachelor Trudeau with Liona Boyd. Following his legal separation in 1977, Trudeau began an eight-year relationship with the classical guitarist. Trudeau and Margaret finally divorced in 1984, with the prime minister retaining custody of their three sons.

167. Trudeau—ever the outdoorsman—in his buckskin jacket. He believed that one can achieve balance through paddling a canoe: a balance between physical and mental pursuits; nationalism and individualism; passion and reason; wilderness and society; and past and present. Trudeau's buckskin jacket is displayed at the Canadian Canoe Museum in Peterborough, Ontario.

169. On February 29, 1984, after what Trudeau described as his 'long walk in the snow', he announced he would not lead the Liberals into the next election. With his approval ratings slipping, polls showed the Liberals bound for defeat if led by Trudeau. He formally retired on June 30, 1984, ending his 15-year tenure as prime minister of Canada, with four election wins (including one minority 'squeaker') and only one loss. He became the third-longest-serving prime minister (after William Lyon Mackenzie King and John A. Macdonald) and the longest-serving prime minister from Quebec.

171. December 20, 1999. Trudeau was named Canada's newsmaker of the 20th century in a Canadian Press Broadcast News poll of newspapers and radio and television stations.

173. Pierre Elliott Trudeau and Deborah Coyne with their daughter, Sarah. At 71, Pierre Trudeau had secretly fathered a baby girl. Deborah Coyne was a constitutional lawyer and had become very close to Pierre in his final years.

175. Skiing was a favourite pastime of the Trudeau family. Tragically, on November 13, 1998, Michel Trudeau, youngest of Pierre and Margaret's three sons, drowned in a glacial lake in British Columbia after being caught in an avalanche while skiing.

177. Justin Trudeau and his father sharing a moment at Michel's funeral.

179. On September 28, 2000, Canada lost its most iconic statesman at the age of 80. This last engraving was made from a piece of maple wood from the tree that inspired Alexander Muir to write the song 'Maple Leaf Forever', an unofficial (English) Canadian national anthem for much of the early 20th century. Although the lyrics have a decidedly British imperialist overtone, and the song was unpopular among French Canadians at the time of its writing, Muir later changed the lyrics to include the French symbol of the fleur-de-lys. The song has had many versions and changes over the years. Similarly, Trudeau recognized that we, too, must constantly adapt. In 1970 he said, 'The past is to be respected and acknowledged, but not to be worshipped. It is our future in which we will find our greatness.'

ENDNOTE

Pierre Elliott Trudeau understood profoundly the way images could convey powerful stories without the aid of words. An expression, a turn of the hand or cast of the eye, a pirouette in a salon—through these gestures he told whole narratives in languages that were all their own, but uniquely his for the telling.

Trudeau's alphabets embraced symbol and device, metaphor and simile to such an extent that his wordless stories contained a pregnancy of meanings that captivated and enchanted those who decoded and read what he was saying visually, silently.

His most allusive messages were those spoken in pictures and in purely visual terms. At a time when electronic media became messages in and of themselves, Trudeau grasped the potential of emblematic actions and attitudes, broadcast in this new environment, to say much without uttering a sound.

Trudeau's wordlessness moved people to act. Enigmatic, mysterious, aloof—in his quiet way he cast spells causing engagements of different sorts. In the muteness of an image, he spoke persuasively. By his actions and example, through the power of an alluring mood, Trudeau described what lay sleeping silently in the hearts and imaginations of his readers.

Articulating the unspoken aspirations of a generation of Canadians in a charismatic pictorial iconography, Trudeau fluently envisioned a society in which all citizens had a voice in its making.

— Tom Smart, Author and Curator
Peel Art Gallery, Museum and Archives

ACKNOWLEDGEMENTS

The publication of this book would not have been possible without the encouragement and help of family and friends. I would like to express my gratitude to everyone who has assisted me with clippings and images to help me construct continuity in my visual narrative. I can't name you all but be assured that every comment and suggestion was greatly appreciated.

My greatest appreciation goes to my wife, Michelle. Also to my two kids and the rest of my family for being loving and supportive. I can't say thank you enough to Robert and Cecily for their support, stories and critiques. Particular thanks are extended to George Elliott Clarke, who provided valuable historical context and important suggestions for images. I am also grateful to Tom Smart, who continues to inspire me. I have accrued many other debts along this journey. My cousin David Hanna helped me communicate with Justin Trudeau's team to acquire permission to use the abridged eulogy that appears as the foreword. I am grateful to both Justin Trudeau and his mother. Margaret Kemper kindly met with me early on in the project to review some of the engravings. Tim and Elke Inkster of the Porcupine's Quill provide ongoing encouragement. I would also like to thank my editorial colleagues and friends Dan Liebman and Michael Worek.